Lunchtime doodles
by DAN LUCAS

A doodle A DAY
 is what I wanted to do
So every lunchtime At Work
A doodle I drew!

I AM the Horn Bird
the 'I dont watch Porn' Bird
the 'I only eat Quorn' Bird
Admittedly,
Im quite absurd.

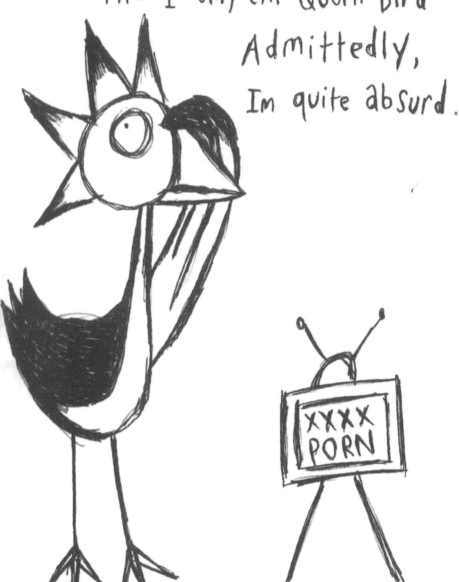

I WAS made
With A big green Pen,

usually
I have no friends,

Cause unless You're born
black, red or blue,

Nobody wants
to draw With you

I AM SQUARE MAN,
SQUARE EYES, SQUARE HANDS,
SQUARE HEART, SQUARE PLANS
SQUARE ISLETS OF LANGERHANS

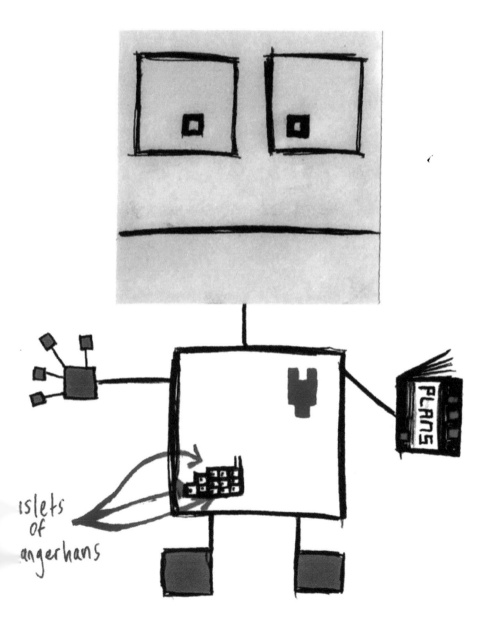

I was born in a Team Meeting, + before the end,
A whole world I was in.

there were plants in the Air,
+ Fish in the ground,
+ little green people dancing Around

there was a strange RED goo
Seeping up through the floor,
+ My tail was held
by a Big RED CLAW

then the Meeting ended,
+ My world stopped growing,
I wonder if next time,
it might start Snowing

I am heart - lip - fish,
I taste good when fried,
I have a tattoo,
running down from my eye.

but there is 1 problem,
Having a Heart for lips,
You fall in love with
your food,

I ♥ chicken
+ chips.

I CAME to BE, on tHE PHONE to SKY
PRESS 1 For Sales, PRESS 2 to Die!
Press 3 For Frustration, 4 For extortion.
PLEASE NOTE: CANCELLING — HARDER THAN HAVING ABORTION
Press 5 For A charge, 6 For a contract,
Press 7 to Wait 2 HOURS + Still No contAct.
Press 8 For 18 MoNths, 9 For 24
AND SMASH the PHONE through
your eyeballs,
 IF YOU CANt
 taKe this,
 No MORE!

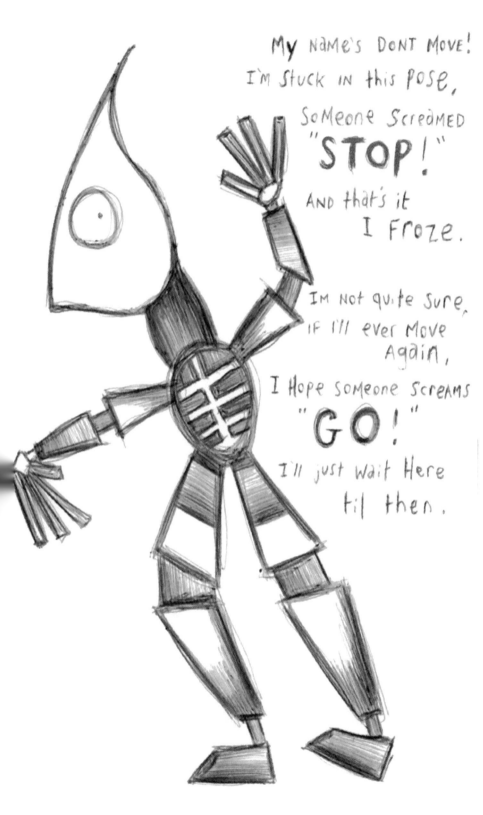

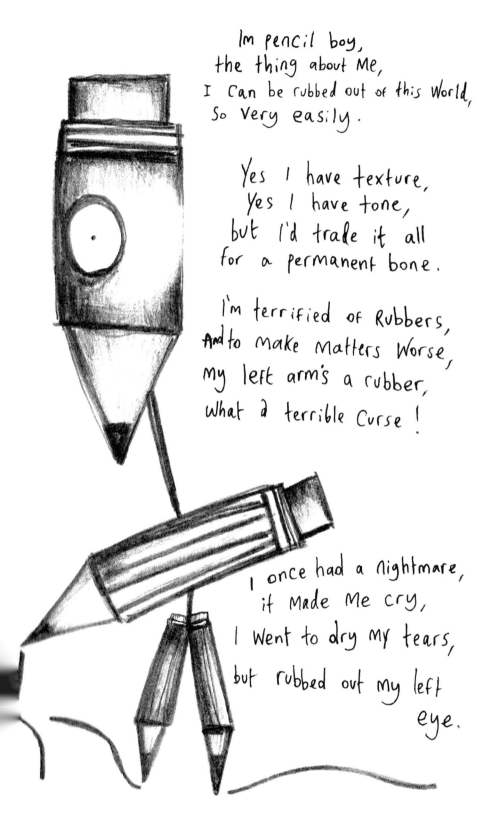

Im pencil boy,
the thing about Me,
I Can be rubbed out of this World,
so very easily.

Yes I have texture,
Yes I have tone,
but I'd trade it all
for a permanent bone.

I'm terrified of Rubbers,
And to make matters Worse,
My left arm's a rubber,
what a terrible Curse!

I once had a nightmare,
it Made Me cry,
I Went to dry my tears,
but rubbed out my left
eye.

I have big orange eyes,
and a little orange nose,
and some nice orange
earrings,
they look good
in photos.

but my world is white!
I dont feel prepared.
I need to live in
Holland,
I'll fit in better
there.

they called Me the white elephant,
they said I was useless.
they said I was boring,
they said I was toothless.

So I picked up a paint brush,
+ painted My Nose.
Painted My skin,
painted My toes.

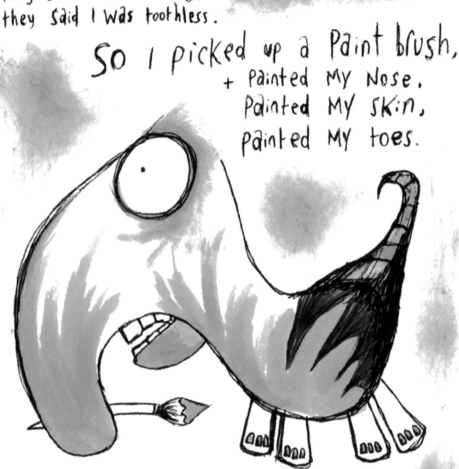

I put in some false teeth,
the finest in dental,
Now they dont call Me the white
elephant,

they call Me 'bit Mental'.

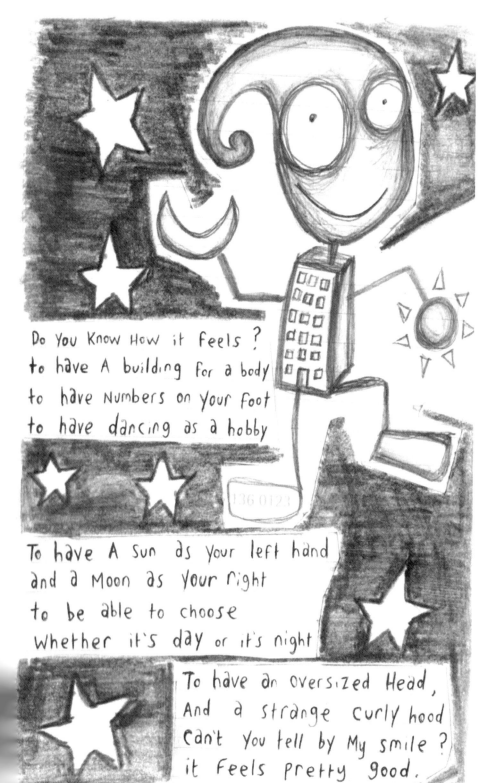

Do you know How it feels?
to have A building for a body
to have Numbers on your foot
to have dancing as a hobby

To have A sun as your left hand
and a Moon as your right
to be able to choose
whether it's day or it's night

To have an oversized Head,
And a strange curly hood
Can't you tell by My smile?
it feels pretty good.

I Had a beautiful girl
I made her cry
she did nothing wrong
the fault was mine.

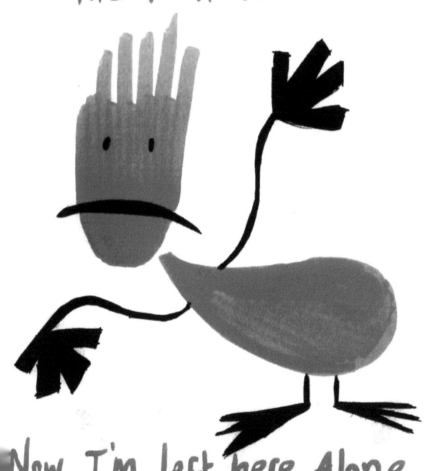

Now I'm left here Alone
feeling hollow inside
Have I made a Mistake?
Should I really have tried?

I dont have enough time
Never Have enough time
Always Need More time
I Wish I had More time

Im running out of*
More time,
Did it feel like this in War
time?
Apparantly its peace time.
but Not on
Middle EAst time.

Or not on Far East
time,
or not on African time,
What even is time?
Do We really Need time?

I AM the post-it MERMAID

I cant live in the sea

because When I get Wet

I get all soft + sloppy

Instead I live in OFFices

on Desks , on Fridge doors

I once HAD to tell A Man

Your girl DON'T Love You No More

I dont love you anymore. Sorry
x x
x

ONCE AGAIN ON the PHONE TO SKY
WHY WHY WHY? WHY WHY WHY?

Why Do I have to wait so long?
Why Does this call
Feel So Wrong?
Why is it all about
MONEY MONEY
MONEY? £

I WANNA CRAWL
INTO MY Shell,

AND DREAM OF BEACHES WARM + SUNNY

I Started off
As a dot-to-dot
 And then becAME
A Sort of chameleon Robot.

HELP!

I Have A sticky tongue
 For catching spiders
 but have No Digestive SysteM
Only Metal AND WireS

I Won this little Monster,
At the local Village Fair,
And then I Won the
 lottery,
A Miracle I
Swear!

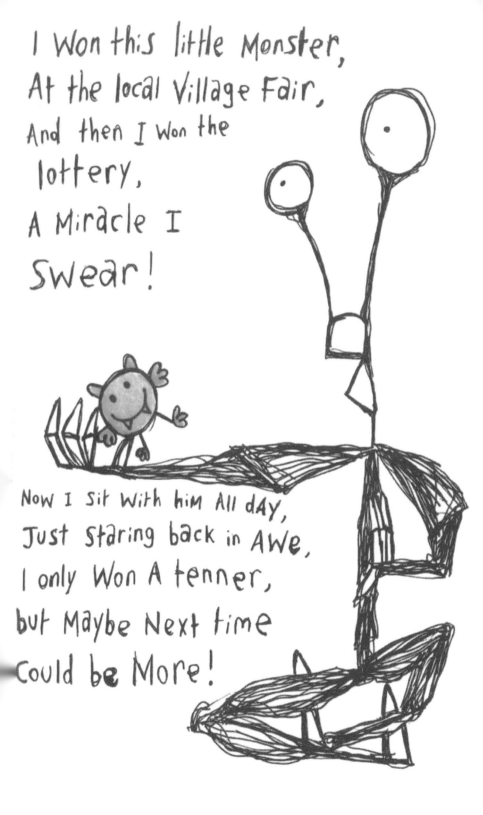

Now I sit With him All day,
Just staring back in Awe,
I only Won A tenner,
but Maybe Next time
Could be More!

IM a complex organism,
there are many parts to me
Far too complex
to explain to you
you see.

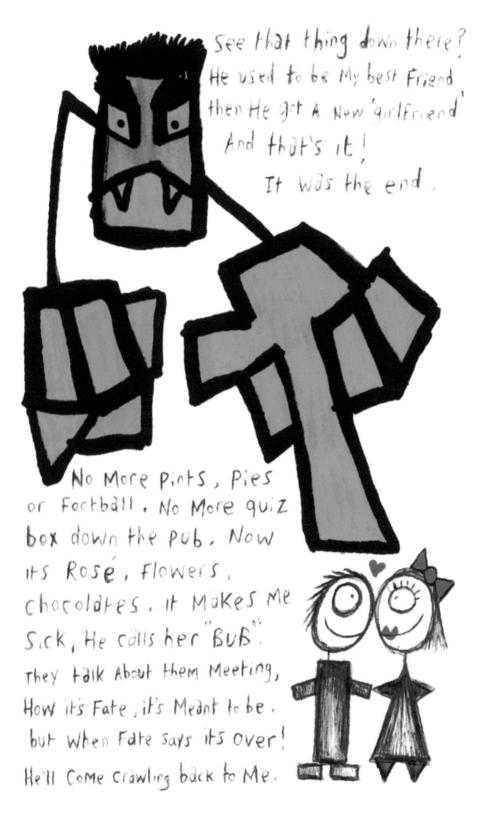

I cant even
look at you

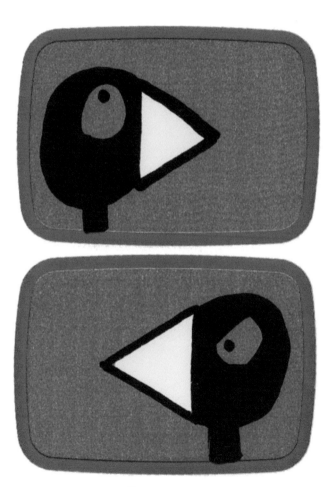

thats it!
we're through

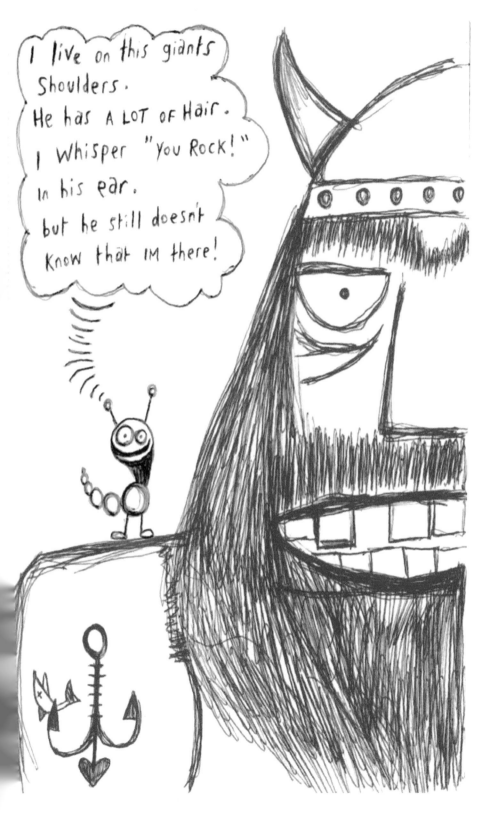

the cubist shark
 Lives in the Dark
 He Makes Dogs Bark
 Makes lightbulbs Spark

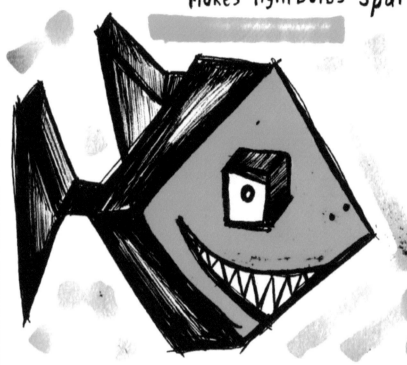

the Cubist shark
 He looks like Art
 Rips you Apart
 He's Very Smart

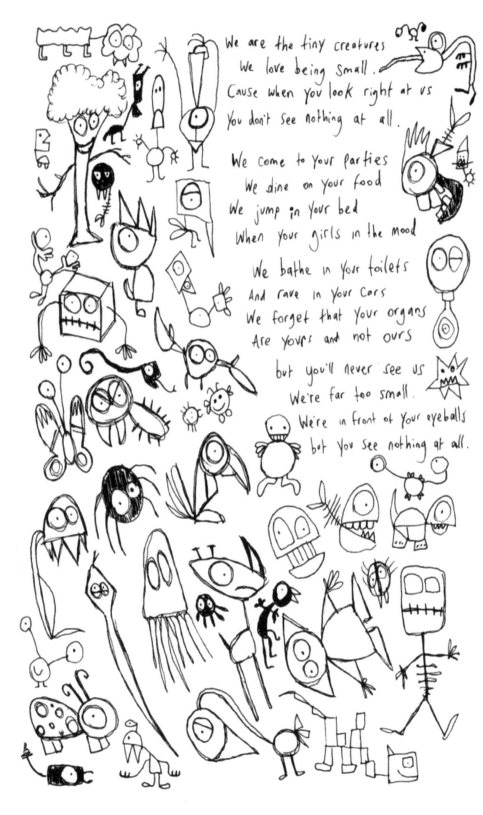

We are the tiny creatures
We love being small.
Cause when you look right at us
You don't see nothing at all.

We come to your parties
We dine on your food
We jump in your bed
When your girls in the mood

We bathe in your toilets
And rave in your cars
We forget that your organs
Are yours and not ours

but you'll never see us
We're far too small.
We're in front of your eyeballs
but you see nothing at all.

I AM the Music Monster
I don't come from down your Way
And I CAN play,

OH I CAN play...

Nothing At all
cause I dont have
any fingers ☹

my lacey gloves will reel you in
seductive smoke will make you sin

my long lean legs will make you weak
my black high heels will make you
shriek!

my firm tanned skin
will make you shiver,
my bright pink lips
will make yours quiver

but under the
glasses, what lies beneath?
Can you really trust,
I'm not really a beast?

▼ 3.47 + 1.689 plc barc $\pm 12(7115)x^2$
▲ 0.084 $\pm xy$ £7.05 Ltd App \pm NAS 04
▼ 10.52 - 0.00005 Ltd goog. ▲ + 74.01
▼ 0.06 \pm 0.084 plc FTSE . $0x^2y$. 40
▲ 7.7784230001 ; 2.0 ; FSE x^2 INDEX
- ☐ 750 + y Σ Ltd = £ 10 : 00 101011011
▲ 189.002 \pm PUR ▽ IG ◯ I \pm NASA. $xzab^3$

the Markets, the Markets!
It's a Numbers based land
the smart tips, the smart tips
We couldn't possibly understand

the stock, the stock!
the Rich get richer
to the top, to the top
We're kept out the picture

the shares, the shares!
to us it looks funny
Who cares Who cares?
Shut up! Spend Your Money

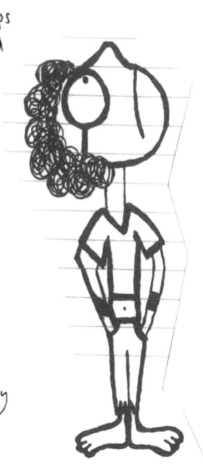

Im the Floppy disk Man
Remember Me ?
Nope. Didn't think so.
Im History

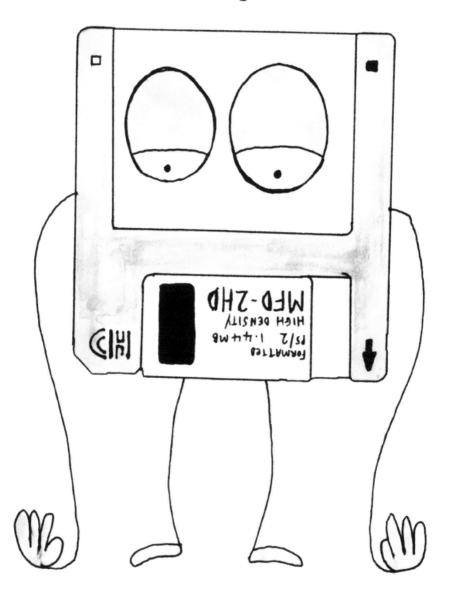

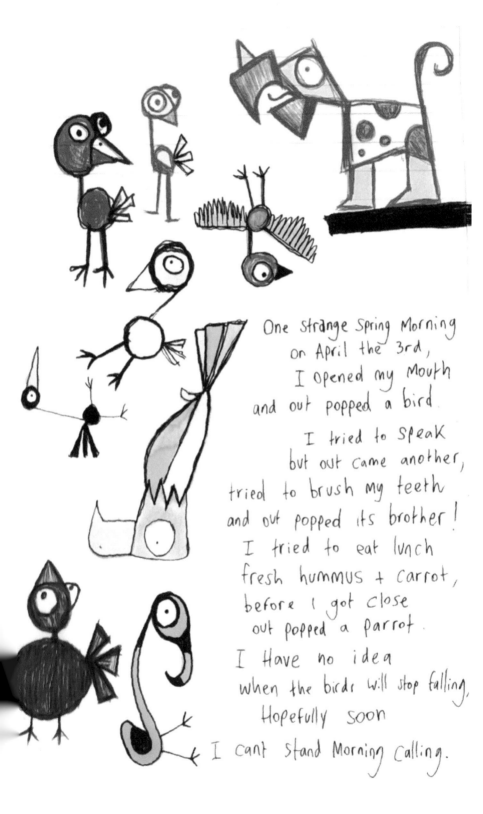

One Strange Spring Morning
on April the 3rd,
I opened my mouth
and out popped a bird.
I tried to speak
but out came another,
tried to brush my teeth
and out popped its brother!
I tried to eat lunch
fresh hummus + carrot,
before I got close
out popped a parrot.
I have no idea
when the birds will stop falling,
Hopefully soon
I can't stand Morning calling.

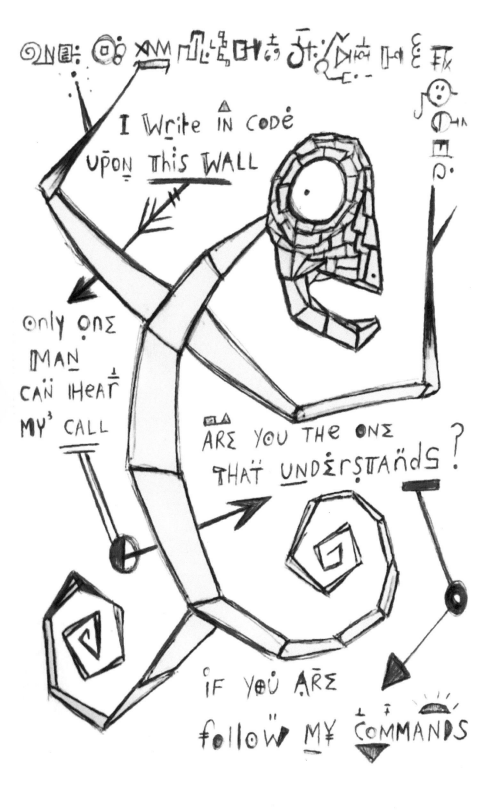

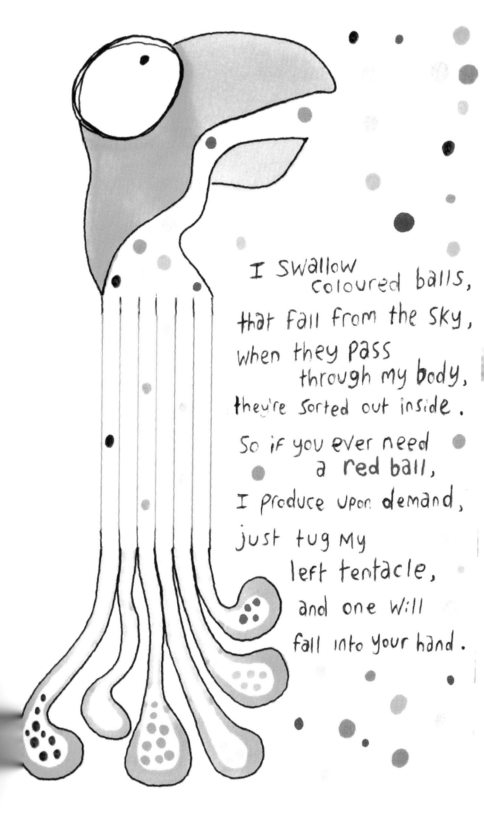

I swallow coloured balls,
that fall from the sky,
when they pass
through my body,
they're sorted out inside.

So if you ever need
a red ball,
I produce upon demand,
just tug my
left tentacle,
and one will
fall into your hand.

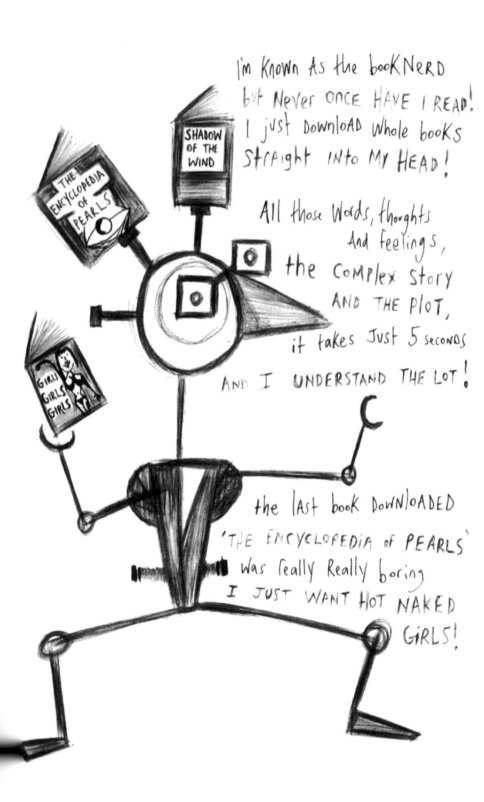

□ ←

I Live inSide this
SQUARE

but you Cant See Me.

You're gonna need A MicroScope

"He He He!"

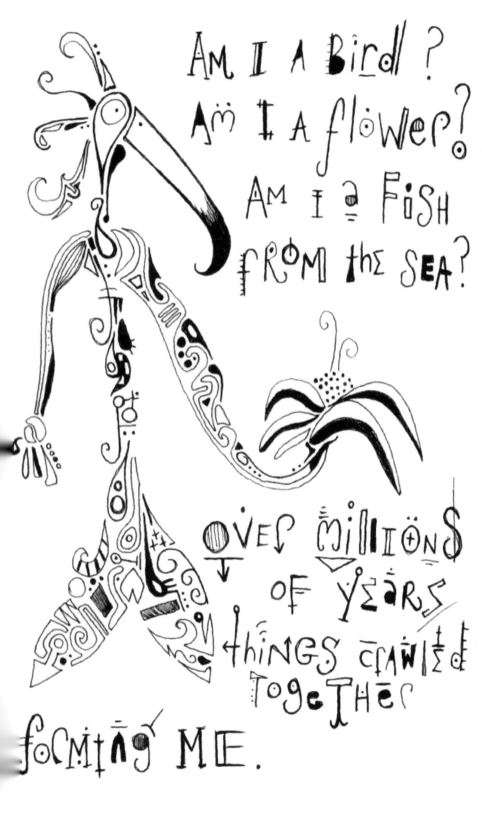

AM I A Bird?
AM I A flower?
AM I a FiSH
fROM the SEA?

OVER MILLIONS
OF YEARS
things cRAWlEd
TogeTHer
foRMiNg ME.

I'm known in the West
As the open-mouthed TOAD.
My tonsils Are traffic lights
My tongue is a roAd.

the cars drive in
they dont Know what they're in for.
the fastiest by far......

Honda 1.8
five door

On one Hand lives A raging Beast,
on the other lives Miss J'adore.
And As He roars,
And as He
spits,
She
loves
Him ♥
More and
More.

Everyday
He starts
on Her,
Waging one
OF his Wars.
And everyday
I ask Myself,

Why Wasn't I born With claws?

TRAPPED IN A BOX
THEY TRY TO LABEL ME
THE DOORS ARE ALL LOCKED
THEY'VE THROWN AWAY THE KEY
DONT KNOW WHERE IM

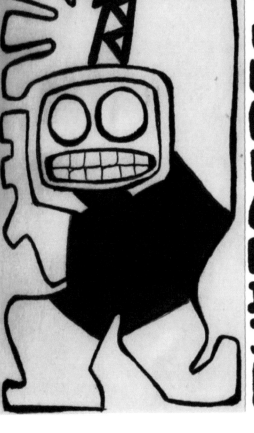

GOING...
DONT KNOW
WHERE I'VE
GONE.
HOW DO I
ESCAPE
FROM HERE
IS IT ALL
JUST A
CON?

I once gave birth,
It was coming of Age.
but as soon as it was born,
it flew onto
the next
page.

I Spend all DAY
looking up to the SKY
Wondering Why
Just Wondering Why

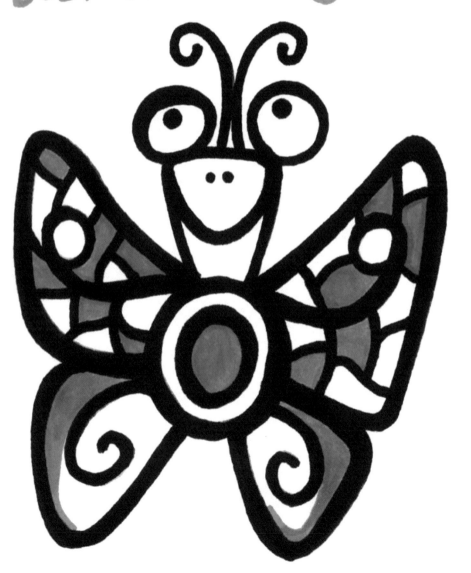

I used to be Art,
but I jumped off the Canvas,
Now Im on the run,
Im heading for Kansas.

Sound Sound
its lost and
its found,

buried into the ground

grows into a mound

turns into a town

it sinks + is drowned

it heads homeward bound

its lost and its found

Sound

Sound

yo Im the urban City poet
if I played Cricket
 I would throw it
if I ripped my Jacket
 I would Sow it
Cause Im the Urban Poet!
mother F***ing urban Poet!
 AARAh yeah....
yo Im the urban City poet
if I had a Sunflower
 I would grow it
if I had a Lawn I would mow
 it
Cause Im the mother
F***ing urban Poet!

AAAhhhhh yeah...
yo Im the urban
 City Poet
IF I had a boat I would Row it
F I had a Chaos pad
 I'd Zane Lowe it
Cause Im the Mother F***ing urban poet!
Cause Im the Mother
 AAAAAAhhhhh yeahhh...

I Live on a hill in the Sea,
With a hibbledee jibbledee tree.
We've become great friends,
dress up on
Weekends,
I call her
Margery.

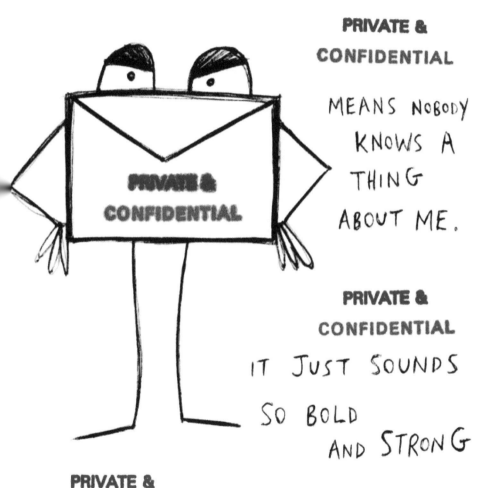

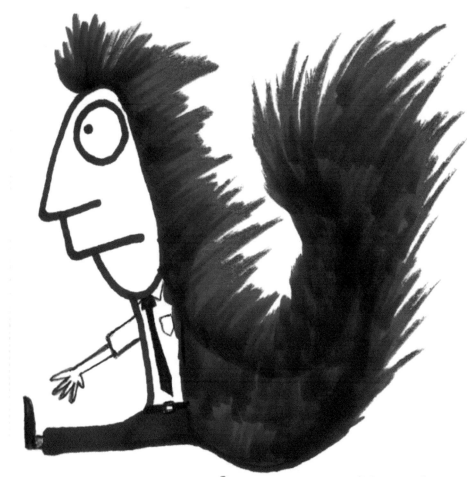

I woke up for work one morning
+ something felt quite wrong,
my hair had gone Red,
to my back it had spread,
into a tail all bushy + long!

I cant get A Job,
No Really, I've tried,
Nobody Will take Me,
I dont Know Why?

Maybe it's the teeth,
Maybe it's the belly,
Maybe it's the Posture,
I Know it looks like Jelly.

but I want to have A trade,
I Want to be Seen,
I dont Want to join
An accounting
Grad Scheme.

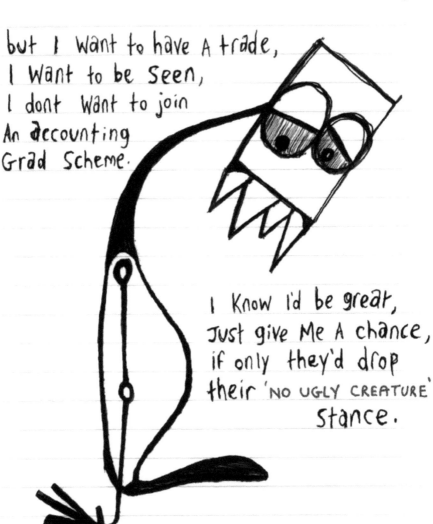

I Know I'd be great,
Just give Me A chance,
if only they'd drop
their 'NO UGLY CREATURE'
stance.

IM the liNED paper Monster
I really HAte lines,
I gobble theM UP!
Five or Six At A time!
I HAte Being told, WHeRE AND when I can Write
And to fit ALL My thoughts in A space that's so tight

I want to Write Big
I WANT to Write SMALL
I WANT to Write UPWARDS
curl into): there Will be No More lines
so WHEN I AM DONE
A ball

Just Wide open pages
And Wide
Open
MindS.

With the Head of A snake,
And the Wing of a bat,
 You'd think I'd be,
 All Evil And that. But I've A
 Sensitive
 side,
 My bottom
 Half shows,
 the
 Breasts
 of Shakira,
 tHe waves
 As My
 toes.

 My Eagle
 Wing,
 Powers
 the tide,

 I Reel in the Surfers,
 My HiPs dont lie.

So tired, So tired
So tired I Feel Weak
So tired, So tired
So tired I Need Sleep.

So tired, so tired,
My eyes feel
like LeAd,
So tired, so tired
I'd give Anything
for a bed.

I Fight all My Instincts,
When I Hear that AlarM,
IM sure once We slept Properly
IM sure once life Was calM.

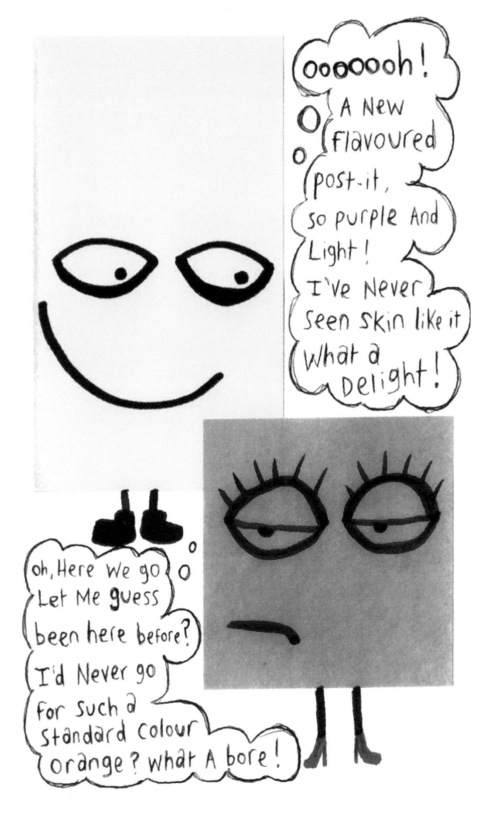

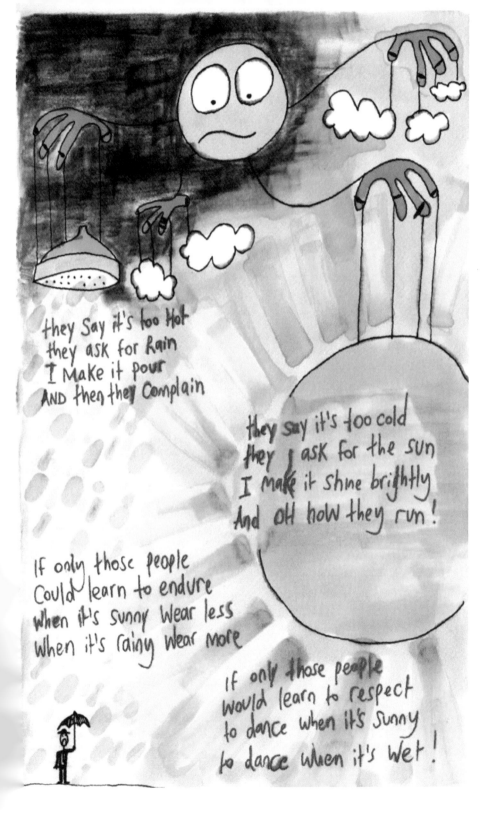

I came to this place
 From A whole different town,
the sky was Black
 the walls were brown.

A strong wind came
 And blew us Apart
 the whole town Crumbled
 We Flew off
 the chart.

For Some unknown
Reason,
 I WAS spared
From it all,
Now I Must
Stay + Cling,
to our last
Piece of wall.

THE TOXOPLASMA PARASITE
CRAWLS INTO RAT'S MINDS
INFECTS ALL HIS THOUGHTS
AND NEUROLOGICAL SIGNS.

THE INFECTION IS CRUEL
ON THE OBLIVIOUS RAT
FOR SUDDENLY IT HAS
NO FEAR OF CATS!

NO LONGER IT THINKS
'THERE'S A CAT I SHOULD HIDE'
INSTEAD IT WALKS FEARLESS
IT'S RAT SUICIDE!

IN FACT THEIR INSTINCTS
ARE SO FAR REVERSED
THEY SEEK OUT CAT URINE
OH HOW **PEVERSE**!

ONCE IN THE CAT'S BELLY
THE PARASITE THRIVES
WITH ONLY TWO AIMS:
REPRODUCE + SURVIVE.

YOU HAVE TO SAY THIS:
LIFE CAN BE CRUEL
BUT **LIFE'S** ALSO GENIUS
OVERWHELMING + ALL.

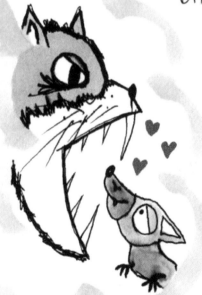

I started As A cactus
I was happy as can be
just sitting in the sun All DAY
All plump And prickly.

but over time I grew some cells
Which turned in to a Brain
And Now I Sit and think All DAY
it really is a pain.

I think About Why I'm here
the Meaning of it All
When All I used to think About
WAS growing green And TALL!

I Hope One day My head falls
off
And Drops in to the sand
So I'll return to HAppy Days
No Worries, thoughts or plans.

.

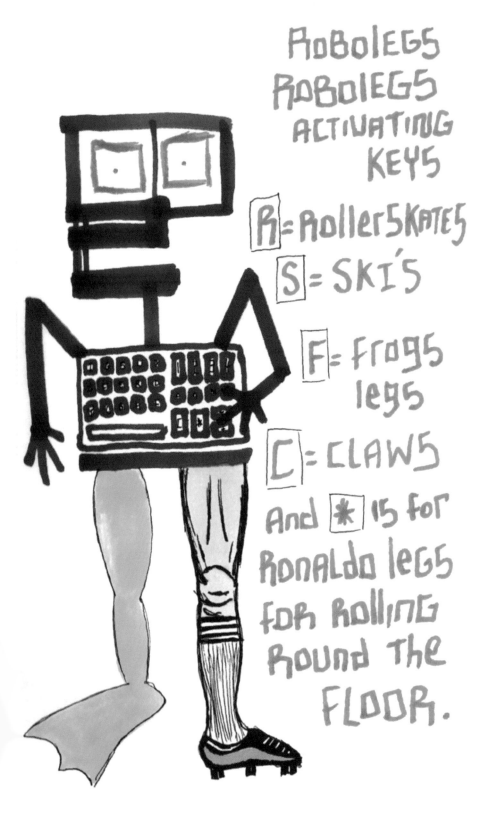

As I peered over the Edge
At the Raging Red green sea
I Had a Moment to Reflect
And turned bAck to sAfety.

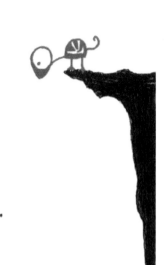

There once was A girl
WHO believed From the start
that doodles Have Meaning
that doodles HAve Heart.

She bought Me A book
Which turned into this
So to her I Say **thank you**
She Knows WHo she is.

thanKs for
Reading ☺

Published by Dan Lucas

www. lunchtimedoodles . co·uK

CPSIA information can be obtained
at www.ICGtesting.com
Printed in the USA
2570LVUK00009B